John Diebboll

The Art of the Piano

· D R A W I N G S ·

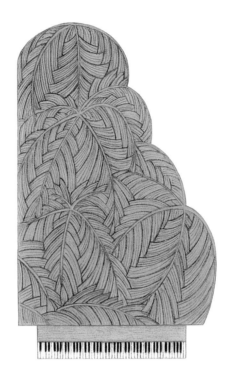

JOHN DIEBBOLL

THE ART OF THE

PIANO

·DRAWINGS·

INTRODUCTION BY
SANDY DAVIS

ℙ

A POCKET PARAGON BOOK

DAVID R. GODINE · *Publisher*

First published in 2000 by
DAVID R. GODINE · PUBLISHER
Post Office Box 450, Jaffrey, New Hampshire 03452
www.godine.com

LIBRARY OF CONGRESS CATALOGING-IN-PUBLICATION DATA
Diebboll, John.
John Diebboll : The art of the piano /
introduction by Sandy Davis. — 1st. ed.
p. cm.
ISBN 1–56792–174–4 (hardcover : alk. paper)
ISBN 1–56792–150–7 (softcover : alk. paper)
1. Diebboll, John—Themes, motives.
2. Pianos—Designs and plans. I. Title.
NA2707.D54 A4 2000
786.2'19'092—dc21 00–061771

Frontispiece and title page:

ETUDE NO. 33, *Palms*. The piano's cover is composed of tightly interlocked palm leaves, each section of leaf a separate piece of colored wood veneer, creating the illusion of a dense tropical canopy that is anything but flat. The piano legs represent the forest below and are rendered two-dimensionally — solid silhouettes that screen the instrument's black and white banded body and completely disconnect it from the keyboard, which appears to be floating. The sounds and light in a rainforest, like this piano, are often illusory and we easily fall for the tricks they play with our senses.

Design by John Diebboll · Layout, composition, and digital imaging by Carl W. Scarbrough
FIRST EDITION · *Printed in Hong Kong*

Introduction

THE CREATION of a series of enchanting art-case pianos by my friend, the architect and artist John Diebboll, began when I asked him to design a twenty-first century piano and lecture for a course I was organizing for the Bard Graduate Center for Studies in the Decorative Arts, Design, and Culture public programs entitled "The Art of the Piano." His lyrical, innovative visions, called "Etudes," "Bagatelles," "Nocturnes," and "Operas," are witty visual poems, combining the intuitive and creative imagination with his architectural expertise, inviting the viewer to see the form of the piano in a new way. These art-case piano designs intended for one-of-a-kind construction take the instrument's traditional form to a new level of understanding. He has continued his investigation of the form to create over two hundred designs.

Musical instrument decoration has been known in all world cultures. Art-case pianos, designed by architects and designers to enhance interior styles, reached full expression in the late nineteenth century and ended with the Great Depression. Because of their artistic, musical, and design importance, examples of historic art-case keyboard instruments have been preserved in the United States in the collections of the Metro-

politan Museum of Art, the Museum of Fine Arts, Boston, the Smithsonian Institution, Yale University Collection of Musical Instruments, and the Shrine to Music Museum at the University of South Dakota (Vermillion).

In an important sense, John Diebboll is returning to the tradition of musical instrument design and decoration. What results is a visionary collection of work, which expands the familiar image of the piano with abstract, geometric, realistic, and musical references. Diebboll's designs are unlimited: an upright becomes a tricolor Australian Shepherd, a grand becomes Frank Lloyd Wright's Guggenheim Museum, the opera *Carmen* becomes a red palm of jealousy and passion. The colored pencil drawings in this collection transcend interior decoration and provide a blueprint for a union of acoustic and visual art, enchanting to both the eyes and ears. Whether designing museums, libraries, schools, theaters, or private homes, he draws spontaneously. Paraphrasing Stravinsky he states, "The phenomenon of architecture, like music, is given to us with the sole purpose of establishing an order in things, including, and particularly, the co-ordination between man and time ... and like music, it entertains us with a complete range of emotions."

SANDY DAVIS, *Curator*
New York City

Foreword

Many musicians and architects have described the relationship between music and architecture. As an architect, I try to design with the spontaneity musicians use to connect with their audience. My bond with clients is similar as we play with the space and materials that will, when the project is built, lift us together like music. The elation we experience during a performance comes from this spiritual connection and has been the catalyst for the work in this book.

Once, in a dream, I was asked to perform an hour of my own music as a solo pianist at Carnegie Hall. The entire concert was completely improvised. I will never forget the energy that channeled from the audience through me and into the piano, or the pure exhilaration afterwards. When I began my "Etudes" series of piano designs a month later, the exhilaration returned and with each new piano the feeling grew stronger. Every piano in this book has a unique identity, inside and out. An artifact that tells a story, whether it's a building, a vase, an automobile, or a piece of furniture, can surprise us, enlighten us, or simply make us smile. The stories in this book revive a tradition that can be applied to anything we choose to design. This tradition comes with a respected set of rules, giving it a sense of perma-

nence. However, there is a paradox: a tradition must experience change or else it will die. In the world of archetypes, our imaginations must collectively create a new synthesis of techniques, materials, and forms in order to nurture this aspect of change. Then, as we create change within the rules of the tradition, we feel a change in ourselves as well.

When you have finished this book, you will experience pianos, architecture, and even your own perceptions from a new perspective. This collection of pianos is part of a tradition that began three hundred years ago. Every design tells its own story, improvising on ancient patterns. The evolution of an archetype, such as a library or a church, is a practical and mysterious discourse that should be fluid and self-revising. The piano's evolution has, for most of the last century, focused exclusively on perfecting the process of mass-production; these designs and hundreds of others celebrate the poetry of the piano in hope of its revival.

JOHN DIEBBOLL
New York City

John Diebboll

The Art of the Piano

· D R A W I N G S ·

Etudes and Bagatelles

THE FIRST PIANOS I designed were follies, part of a series that I named "Etudes." They were whimsical and quick, derived from familiar objects, furniture, and buildings. Without exception, each design appeared to me fully formed; I merely had to draw it.

The "Bagatelles" take this playfulness to another level. The simple form of an upright, compared to a grand, places fewer limitations on the designer and the results are more spontaneous. Most of the "Bagatelles" were created from the amalgamation of two seemingly unrelated subjects, and can be seen as sculptural haiku.

A piano's personality, in particular its voice and action, develops over time. With an art-case piano, there is an opportunity to endow the instrument with more than acoustic qualities. These pianos express their personality on many levels — hence when they're not being played they continue to be heard.

ETUDE NO. 7

ROEBLING

10 1/2 x 13 INCHES

A SENSE OF WEIGHTLESSNESS often contradicts the heavy materials used to build a bridge, not to mention the tremendous forces of tension and compression that are rarely "seen." Similar forces are hidden inside every piano, particularly grands. Roebling's bridges were suffused with classical proportions and details, which he used carefully to dramatize the structural elements. This piano's wooden case is clad with copper sheets and suspended from two stone pylons by steel cables.

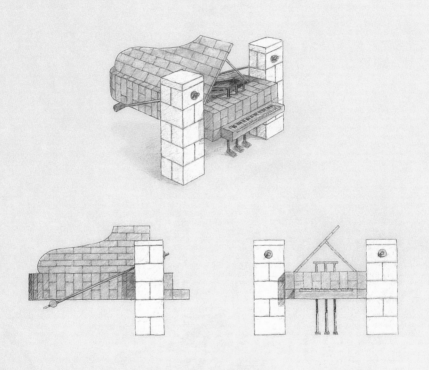

ETUDE NO. 12

GUGGENHEIM
10 1/2 X 13 INCHES

FRANK LLOYD WRIGHT designed several pianos but nothing like this. His museum on Central Park in New York was my first lesson in changing the rules of architecture. Growing up in Michigan, I began studying his life and work when I was nine; changing the rules came much later.

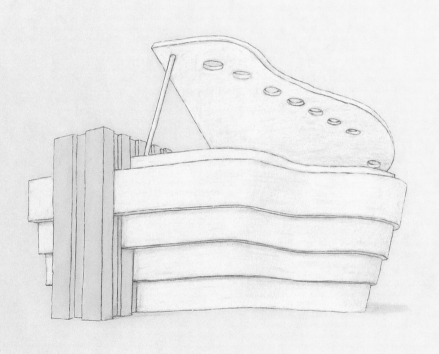

Etudes Nos. 18–21

HELFGOTT

11 1/2 x 17 INCHES

SHORTLY AFTER seeing the movie *Shine* and hearing him perform at Lincoln Center, I had the privilege of meeting David Helfgott and was overwhelmed by his unusual warmth and energy. His hands are like water: they can be gentle and soft or they can crash upon the keys with the ocean's rage. These quick sketches were a gift to him and his wife, Gillian.

SWIMMING SHORE TO SHORE,

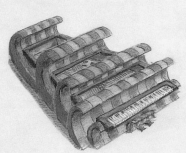

LIMNING MUSIC FROM THE WAVES,

HE PLAYS, PLAYS, AND PLAYS.

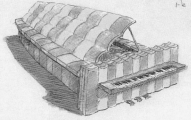

ETUDE NO. 30

MURPHY
4 1/2 X 6 INCHES

THE VALUE OF SPACE in a New York apartment challenged me to invent a way to have a grand piano without having to lose a living room. Counter-weights of cast iron inside the cabinet allow the instrument to be folded away with minimal effort.

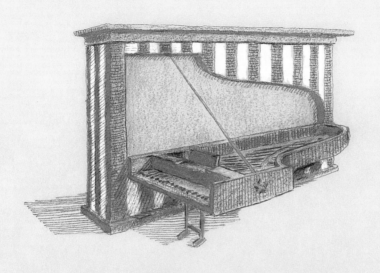

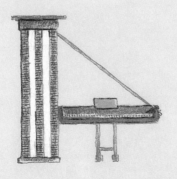

Etude No. 31

DECO

12 X 28 INCHES

This design was the first to express the piano's internal structure as the primary idea and it became an antecedent for many of my other designs. An outline of the framework's pattern was delineated with contrasting veneers of maple and cherry to recall fabrics and furniture from the 1930s.

In the collection of Bruno, Cheryl, and Pierre Henry

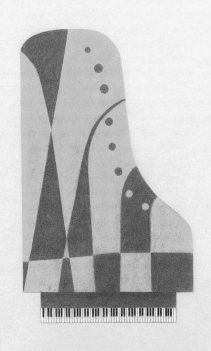
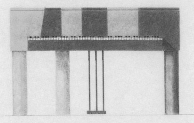

ETUDE NO. 32

CHRYSLER

12 X 28 INCHES

AFTER FINISHING 'Deco,' I drew this design, which is based upon the building and the automobile of the same era, as a counter-point. I realized that this aerodynamic interpretation of a grand piano's serpentine side was only one of countless associations to be made. Like 'Deco,' this also became a model for other designs.

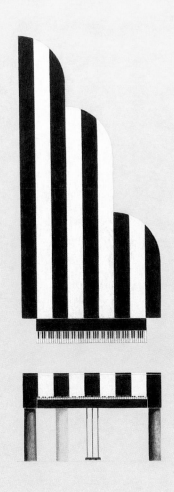

ETUDE NO. 35

ISLANDS
4 1/2 x 6 1/2 inches

When I was ten, my father built a Japanese-style Zen garden as an extension of the front entrance to our house in what was then a rural part of Michigan. I remember having to rake gravel to make waves around ancient volcanic stones — a miniature world of islands that my five brothers and I would destroy and restore every day.

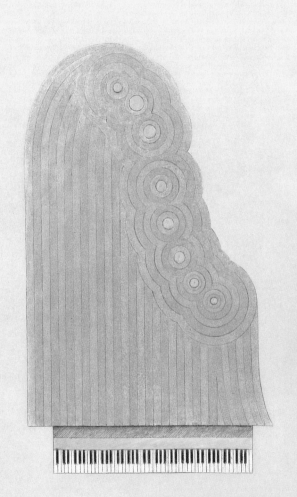

Etude No. 37

SAIL

4 1/2 x 6 1/2 inches

In a children's story, centered on a musical prodigy named Nathalie who dreams of adventures to undiscovered places, a piano is transformed into a sailboat and becomes her sole means of transportation.

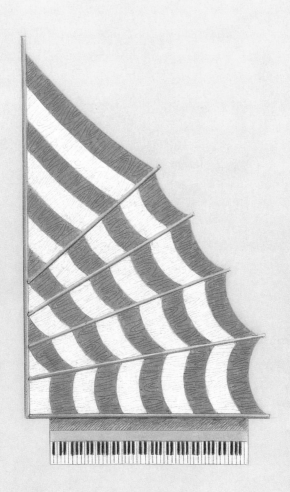

ETUDE NO. 42

DINER

4 1/2 x 6 1/2 inches

The original ones (favored by Hollywood) have become an American architectural icon worthy, in some cases, of historical preservation. Late one Sunday night in autumn, as I was returning from my home in the Catskills, I stopped at my favorite in Monticello. Sitting at the counter, the idea was served to me with a piece of pie ... who created quilted metal and why?

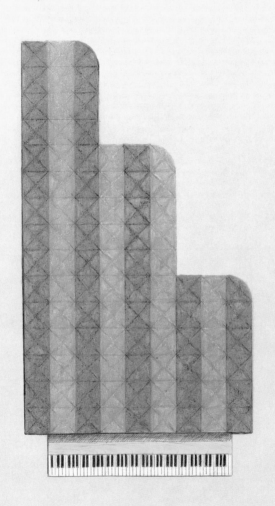

Etude No. 43

TORTOISE
4 1/2 x 6 1/2 inches

THIS DESIGN was done for my son, Isaac, whose favorite animals are turtles.

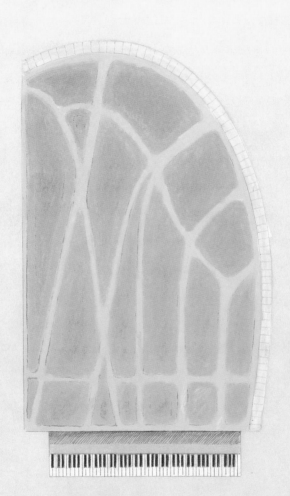

Etude No. 44

BAMBOO

4 1/2 x 6 1/2 inches

In the solemn world of piano-making, there is an ancient taboo that keeps the Steinways, the Bösendorfers, the Yamahas — in short, all the manufacturers — from looking at bamboo. When will they see its beauty or acknowledge its versatility?

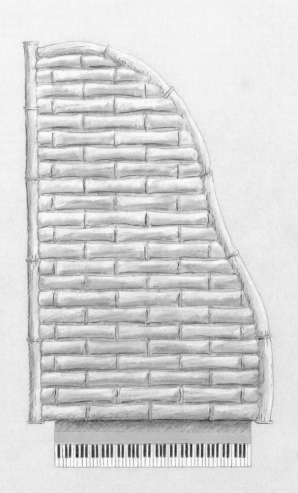

BAGATELLE No. 34

RETINAL RUSTICATION

8 1/2 X 11 1/2 INCHES

WHILE SITTING in my ophthalmologist's waiting room, I began to sketch optical illusions to pass the time. These rapidly transformed into a small series of uprights, experimenting with the grain patterns in various wood veneers. By the time Dr. Odell called me into his office, the uprights had evolved into rusticated walls.

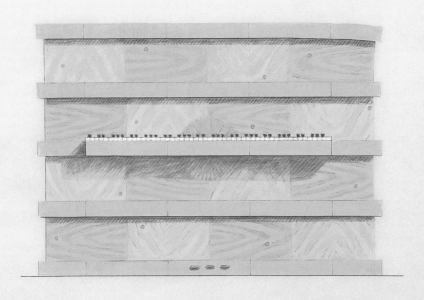

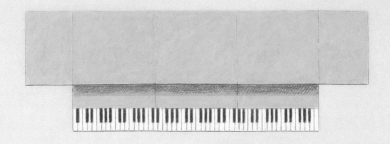

Bagatelle No. 26

AUSTRALIAN TAZIOLI

8 1/2 x 11 1/2 inches

There is a tri-colored Australian Shepherd in Lawrence, Kansas, that occasionally writes letters to me. He once sent me a self-portrait photograph and the profile of his body reminded me of a Fazioli grand placed on its side. The dog's name is Tazzie.

In the collection of Sandy Davis

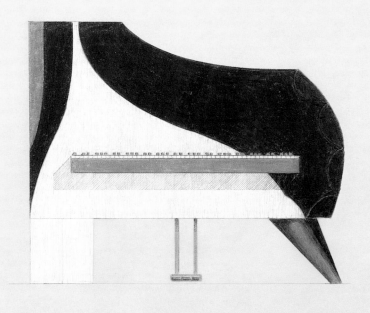
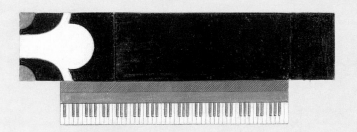

BAGATELLE No. 1

PERSIAN MINGUS
8 1/2 x 11 1/2 INCHES

THE PIANO'S SHAPE has been altered to recall the body of Mingus's bass. It is coated with a Persian-blue lacquer and script-like gestures of silver leaf, creating the ground for the keyboard-patterned inlay that was developed in Nocturne No. 5, a grand piano inspired by Mingus's music the previous year.

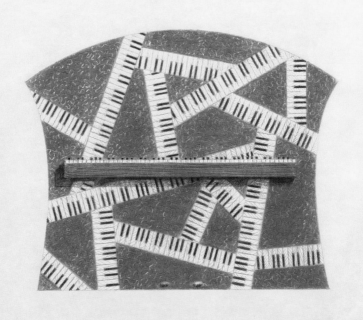

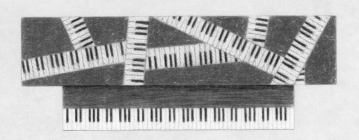

BAGATELLE NO. 33

FORBIDDEN HOLSTEIN

8 1/2 x 11 1/2 INCHES

IN 1981, during a week in Beijing, I began each morning at dawn exercising in Tiananmen Square. Afterward, staring at the red walls of the Forbidden City, I began to see the huge red barns of Michigan's dairy farms bursting at the eaves with golden hay.

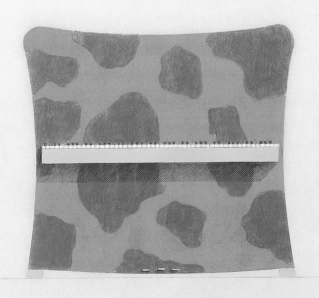

BAGATELLE NO. 32

MBIRA PROVENÇAL

8 1/2 x 11 1/2 inches

THE FIELDS OF LAVENDER in southern France distort the landscape with simple geometry and color that vibrates and imitates the flattened spokes of the thumb-piano (*mbira*) next to my bed — its wooden soundbox resonating with memories of the Serengeti.

BAGATELLE NO. 31

TANZANIAN TULIPS

8 1/2 x 11 1/2 INCHES

IN 1979, I lived in Tanzania, working with architect James Rossant on the design for a new capitol. The day of my return to New York, I bought ebony in Dar-es-Salaam and flowers in Amsterdam.

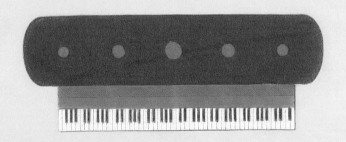

Nocturnes and Operas

The "Nocturnes" series uses portraiture to create pianos that are mostly about musicians whose work has influenced me. Some are about friends or places, and at the end of each year there is one in honor of the holidays. I usually develop the design while listening to the subject's music, and use the piano's internal structure as an abstract armature to build upon. In this way, the instrument's anatomy becomes a stable counterpoint to the improvisational work with colors, shapes, and lines. References to specific aspects of the subject's life add still another layer to the design. My intent is to portray a melding of two spirits: the subject and the architect. They are nocturnal searches for iconographic metaphors found and colored to convey the melding of one to the other. Each piano owns its own sound — seen, heard, and felt — just as no voice is the same as another. Just as each house, garden, and building is a portrait to play out loud, their spirits surround us day and night. The "Operas" are also portraits. Like their subjects, they are inherently complex. Elements of the libretto, setting, structure, and emotional intent have been integrated in designs that also mirror the piano's internal structure. They are both graphic documents of the drama and poetic interpretations of the music.

Nocturne No. 1

RANDY WESTON

10 1/2 X 13 1/2 INCHES

Randy was the first musician to see the new pianos I was creating and became the inspiration for the first "Nocturne." He had recognized the African influences in some of the designs, not knowing that I had lived in Tanzania. His music and life encompass a dream of global unity, celebrating ancient African precedents and the potential to transcend ethnic boundaries.

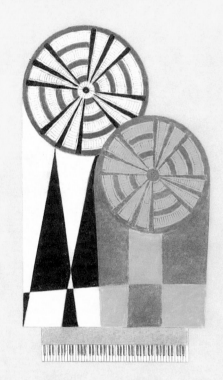

Nocturne No. 12

DAVE BURRELL

10 1/2 x 13 1/2 inches

The first time I heard Dave play, we were alone in a piano showroom. He slowly poured himself into the keys and the music started to rise around me like an ocean tide. Soon both of us were in a trance navigating through each season, encountering squalls and flats and everything in between. For forty minutes I leaned into the piano as if I were sailing; the wind swirling, shaking, and cradling me with raw joy. When he stopped, the currents continued to carry me back to shore and I began to breathe again.

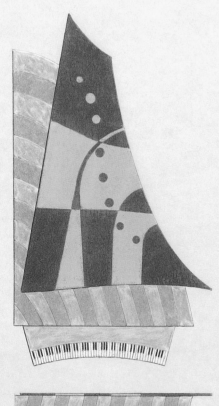

NOCTURNE NO. 5

CHARLES MINGUS
10 1/2 X 13 INCHES

Browsing in Soho's flea market, I was surprised to find Mingus's first recording of solo piano pieces. After the second hearing, the shape of his bass emerged from the case's curves, which was already cloaked in gold, followed by a pattern of colliding keyboards.

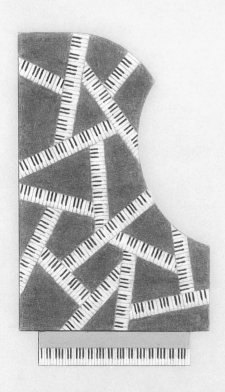

Nocturne No. 6

MONK

10 1/2 x 13 inches

He played slowly when he played alone, weighing the silence between each note and chord. He sent dissonance into other dimensions and somehow found ways to shift silence. The patterns he played were portraits of his genius.

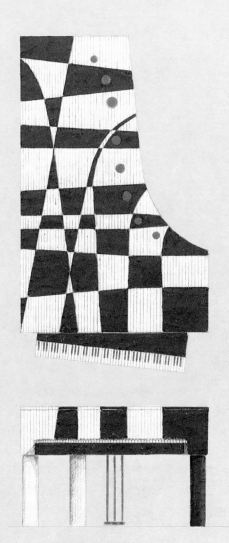

Nocturne No. 16

HOMAGE TO PHILIP GLASS

10 1/2 x 13 1/2 inches

Twenty years ago, I was a student studying architecture. Through my designs, I often distilled elements found in traditional methods of Japanese construction and used them to explore the principles of minimalism. The trouble truly began when I mixed in Palladian proportions and color systems from the Sufi tradition in Persian architecture. I was obsessed with geometry and numerical sequences. Every night I would draw, while listening to *Music in Twelve Parts, Einstein on the Beach, North Star,* and *Dance.* The inspiration for this piano was *Metamorphosis,* one of his solo pieces.

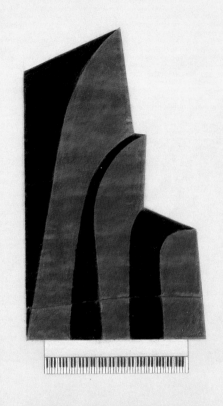

Nocturne No. 19

ALFRED BRENDEL

10 1/2 x 13 1/2 inches

I HAVE DRAWN from three important biographical facts about Brendel: his spiritual home is Vienna, he is interested in late Baroque architecture, and he began his adventure with Beethoven almost forty years ago. I focused on his conviction that the modern grand is a more appropriate instrument than the *Hammerklavier* for conveying Beethoven's music.

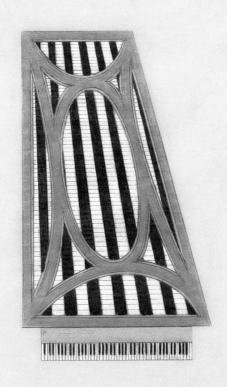

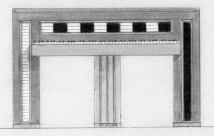

Nocturne No. 21

GARRICK OHLSSON

10 1/2 x 13 1/2 inches

THE CERAMIC CASE of Ohlsson's piano resembles a large container with the keyboard supported by several bottle-shaped legs, two common vessels for storing valuable commodities. Traveling around the world, he transports vast amounts of music, collecting and sharing the old and the new.

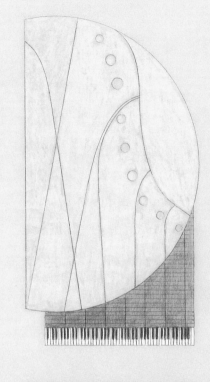

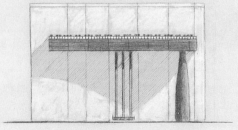

NOCTURNE No. 7

HÉLÈNE GRIMAUD
10 1/2 X 13 1/2 INCHES

IN A RECENT ESSAY entitled "Of Wolves and Men," she says, "I have learned a lot from wolves. Just watching them reminds me how important it is to experience and enjoy every moment to the fullest, and not ruminate on the past or the future." When Hélène introduced me to the wolves she cares for, I absorbed this lesson with patience and silence. When the intense summer heat sent each of us searching for shade at the edge of the woods. I watched them watch me. The afternoon passed, alternating between worlds of shadow and light.

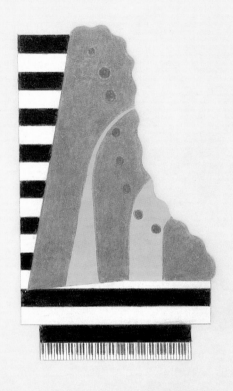

NOCTURNE NO. 22

KEITH JARRETT
10 1/2 X 13 1/2 INCHES

His concerts introduced me to improvisation — how to let go of myself and allow the music to speak directly from my heart. In the privacy of a friend's studio secluded in the Catskills, I would improvise for hours on an old cherry upright. Sunlight filtered through diamond-shaped windowpanes onto the black and white bands of an African fabric hanging on the wall above me.

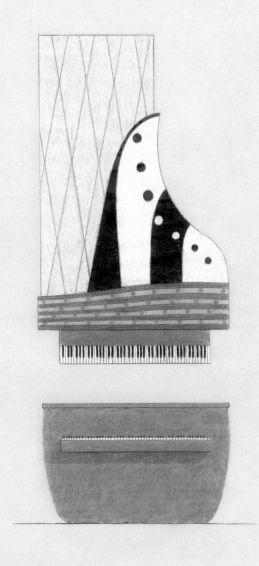

NOCTURNE No. 33

GERSHWIN

10 1/2 X 13 1/2 INCHES

A MAN AND A WOMAN dancing together — two disparate tor-
sos juxtaposed in unison. She is lyrical and romantic, while he
is percussive and propulsive. The Astaires could make his music
visible to an audience, illuminating patterns of jazz and wit
that made it impossible to sit. The improvisational rhythmic
gestures became integral with the instrument's stylized inter-
nal structure. The result is grandiose and feels entirely right.

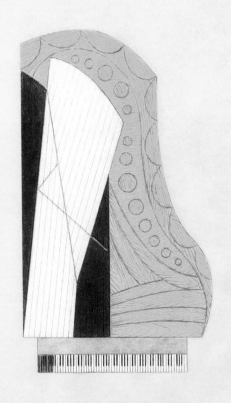
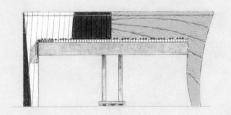

Nocturne No. 11

GLENN GOULD

12 x 28 inches

Gould built a tightly structured pattern of habits with his life and maintained his privacy within the walls of a recording studio. Two walls are conspicuously integrated into this case: a flat rectilinear one that hides the audience, yet has a window allowing the feet to be seen, and another that reflects the sound back into the piano. The case is finished with metallic lacquers in a pattern that reflects the piano's internal framework.

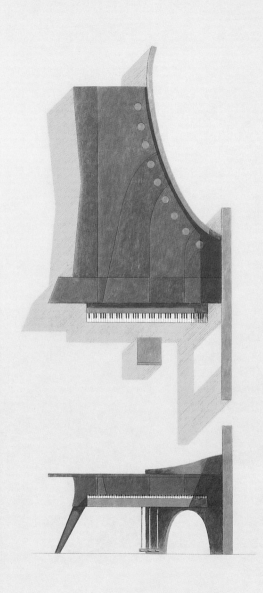

Nocturne No. 38

BILL EVANS

10 1/2 x 13 1/2 inches

It was only recently that I learned of the relationship and similarities that existed between Evans and Gould. This design is a lyrical improvisation on Etude No. 31, using a Bösendorfer frame. His habit of composing spontaneously on paper napkins, like an architect, inspired the notations that track freely across the case between staves. The subtle concavity where the action penetrates the body creates a space to rest one's forehead on the extended keyboard.

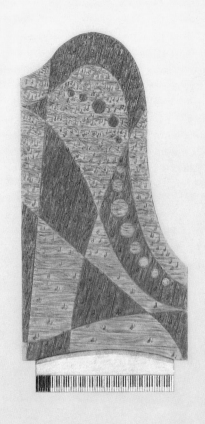

Nocturne No. 37

HOMAGE TO V.M.

10 1/2 x 13 1/2 INCHES

THE PIANO backing him on "Have I Told You Lately," which he wrote and recorded in 1989, inspired this design. It is a love song, and he reveals his heart in the darkness of night. It is a song about the transition he has made from one relationship to another. It is a declaration of absolute trust.

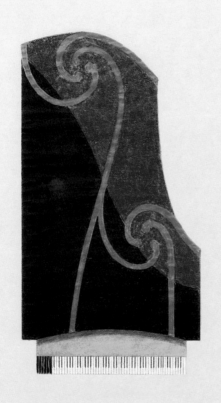

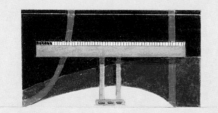

Nocturne No. 26

LIZ GORRILL
8 1/2 x 11 1/2 inches

THIS PIANO is the fourth in a series of five designs; portraits of Liz and of the improvisations that she created in response to my early "Etudes" designs. The trio of silver fiddleheads mirrors a sense of explosive growth about to take place, in her work as well as in mine. The thin legs, a choir of saplings, carry the case effortlessly, as if they were raising it higher, like their leaves, to the sun.

In the collection of Liz Gorrill

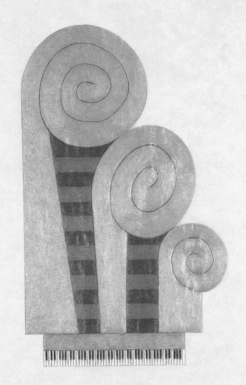

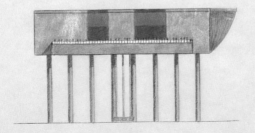

Nocturne No. 28

ODE TO JOY
8 1/2 x 11 1/2 inches

Inspired by the botanical imagery in five previous "Nocturnes," I created my first piano for the holiday season. A chorus of holly leaves derives its shape, once again, from the piano's internal framework. Candles, carols, and whiskey created the mood.

In the collection of Sandy Davis

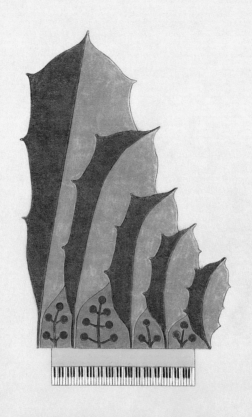
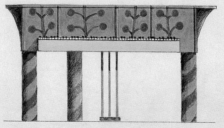

Nocturne No. 44

CAROLLING KEYS

10 1/2 x 13 1/2 inches

The third in my annual series of holiday designs can be seen as a harmonic counterpoint to "Ode to Joy." The composition of cane-shaped keyboards is a variation on the same structure, while the rich red lacquer is an intense complement to the original holly green.

In the collection of Sandy Davis

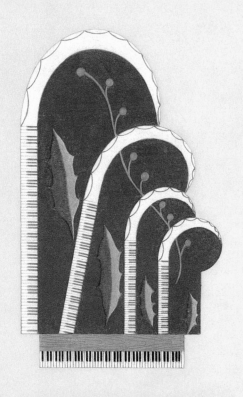

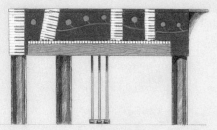

Nocturne No. 9

LEO KOTTKE

10 1/2 x 13 1/2 inches

I BEGAN PLAYING the guitar when I was nine. Ten years later, after hearing Kottke for the first time, I gave it up and started collecting his albums instead. When he plays, you believe that his guitar has hundreds of strings. In this design, eighty-eight strings are pulled to tension above a black and white soundboard, suggesting the lamination of several monumental guitar necks. The goose flying above the keyboard is an obscure reference to the quality of his voice.

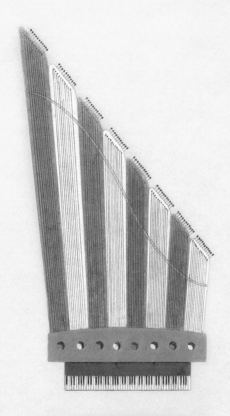

Nocturne No. 34

CINDY SHERMAN

10 1/2 x 13 1/2 inches

Her photographs caused me to stop and look at my own work from a new perspective. The case began as a black box trailing a black curtain, an image that suggested both a stage and a camera, but was soon covered by a costume of gold and silver stripes. A large section of the cover has been cut away, revealing a bloody soundboard beneath the strings and a bone-white frame above. This piano presaged the "Operas" series that follows.

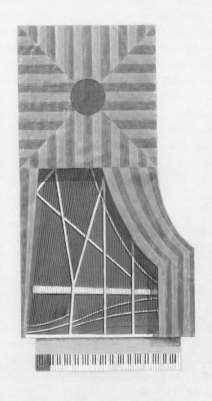

OPERA NO. 6

MAESTRO ON THE MET

8 1/2 x 13 1/2 INCHES

THE UNMISTAKABLE FAÇADE of the Metropolitan Opera House at Lincoln Center stands above the keyboard; it is a podium for Maestro James Levine to oversee the world of music. His influence has spread far beyond the walls of the Met, east and west, and across both oceans. In his biography of Levine, Robert C. Marsh recalls this quote: "I want to make myself obsolete in the concert itself. I want to be able to have the conception seem to emanate from the orchestra members, who are, after all, the ones with the instruments, instead of the crazy magician with a stick who is making all the gestures and telling the audience what they ought to be feeling and hearing. I would like to get to the point where the audience would have the feeling they don't see me."

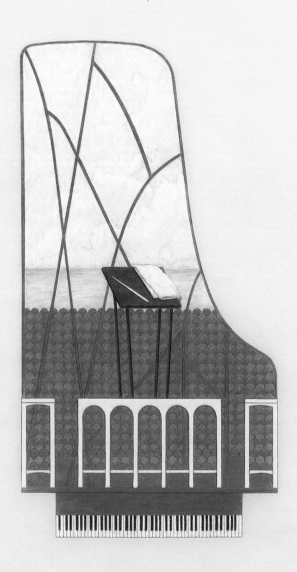

Opera No. 5

MADAMA BUTTERFLY
8 1/2 x 13 1/2 inches

T HE FLESH-COLORED CASE, shaped like the wing of a butterfly, is divided into three views of the same Japanese farmhouse, one for each act. From left to right, the views progress from a distant perspective in the garden to a microscopic close-up of the paper wall pierced with three holes that pull one inside, again reflecting the opera's structure. Each of the characters is represented by a piece of bamboo, Pinkerton and Cio-Cio-San in gold, the others in silver; their positions mirror the internal framework of the piano. The undisguised presence of the *Star Spangled Banner* in the score inspired the keyboard's coloration. The opera's themes of emotional and cultural conflict are expressed architecturally in my delineation of the farmhouse, which parallels Puccini's development of Cio-Cio-San's character from begining to end.

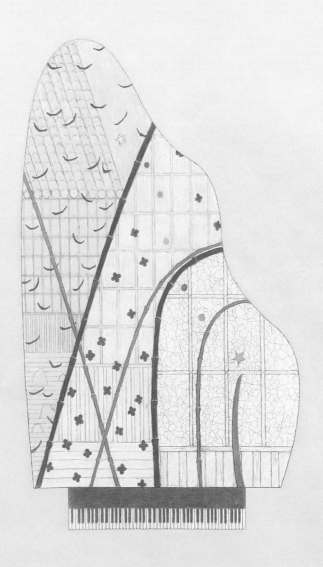

Opera No. 4

AÏDA

4 1/2 x 6 inches

The symmetrical case resembles a sarcophagus, with a spine marked by symbols of the Egyptian gods. Sky-blue bands with evenly spaced stars establish the design's underlying structure, while the space between each band contains the action in each of the four acts, progressing from top to bottom, with each act divided into two scenes by the spine. The five primary characters, represented by masculine and feminine columns that move in and out of the shadows as they appear in the opera, are placed as a group on either side of the spine: Radamès is flanked on the left by Amneris and her father, and on the right by Aïda and her father. The setting by the Nile in Act III causes the black and gold backdrop to change from a brick pattern to a pattern of waves. In the final scene of Act IV, which occurs on two levels, we see Radamès and Aïda entombed just above the keyboard. The grandiose production envisioned by Verdi demanded a design of equal architectonic conviction.

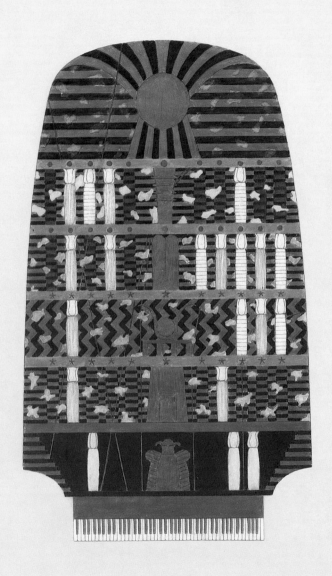

Opera No. 3

CARMEN

8 1/2 x 13 1/2 INCHES

The "Gaudì-esque" shape of the case was traced from my open palm, as if I were somewhere in Spain waiting for my fortune to be told. Lines of love and fate are completely entwined. Carmen is an undulating ribbon, the blood-red color of a cassia flower that becomes black when she dies. Don José is a silver lance that weakens and bends with each of the four acts. Micaela's bright yellow braid falls from top to bottom, passing through each act straight and true. Escamillo's crimson spiral ends with the death of the bull in the final act. For Bizet, the dialogue and staging were not essential to convey the opera's theme, for he had found a way to express jealousy and passion with just the music.

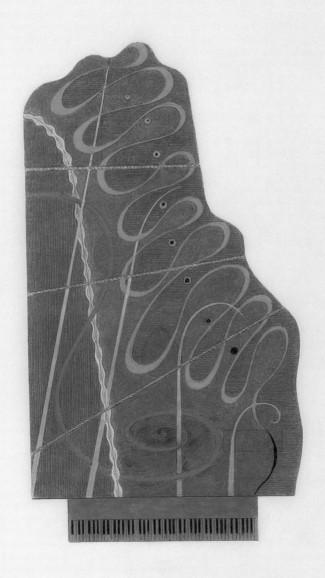

OPERA NO. 2

HOMAGE TO EINSTEIN ON THE BEACH
8 1/2 x 13 1/2 inches

A STRUCTURAL ANALYSIS of this opera is one of several thresholds used to enter this work. The five "Knee-Plays" are seen as the hand of a clock moving across the case in a clockwise direction, passing through day and night. Between each of the "Knee-Plays," the four acts occur in two parts. There are three visual themes: a landscape seen at a distance (the Field / Spaceship scenes), still-lifes seen at a middle distance (the Trial scenes), and portraits seen as in a close-up (the "Knee-Plays"). The abstracted imagery refers to things associated with Einstein: elevators, space rockets, gyroscopes, watches, compasses, plumbing pipes, and the violin. The design of this piano is an articulation of the opera's cyclic structure, co-created by Philip Glass and Robert Wilson, that upholds their process of abstraction, their visual themes, and their belief that "the power of the work is directly proportional to the degree to which we succeed in personalizing it."

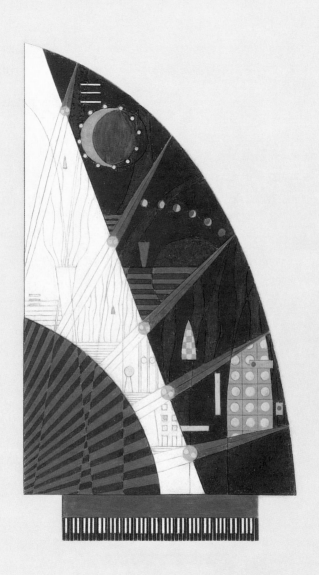

Opera No. 1

THE MARRIAGE OF FIGARO
8 1/2 x 13 1/2 inches

The piano, in the late eighteenth century, was still considered a new instrument — hence the shape of this design recalls its early form. The four distinct panels, resembling sections of musical staves, correspond to the opera's acts. Three pairs of wide curvilinear bands denote six of the principal characters from left to right: Figaro and Susanna, the Count and Countess, Cherubino and Barbarina. Similarly, the thinner threads represent the less important characters. Seen all together, they create a tapestry with sections of gold and silver marking the opera's arias and duets, emphasizing the series of discreet musical events that Mozart composed in a single key to a fixed rhythm and tempo. The interwoven relationships have been abstracted in a manner that alludes to the symmetrical phrases and steady harmonic organization that Mozart perfected.

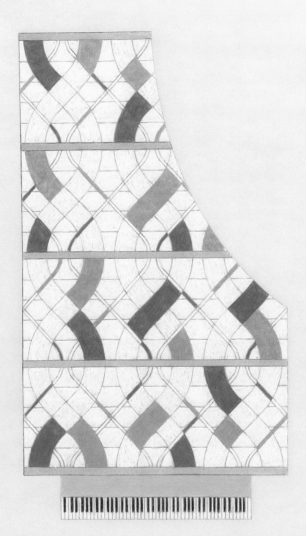

About the Author

JOHN DIEBBOLL was born in Washington, Michigan, a small rural town north of Detroit. The eldest of eight children, he was greatly influenced by his father, a potter and painter. He attended the Kingsbury and Cranbrook Schools in Michigan before moving to Vermont, where he received his Bachelor of Arts from Bennington College. In 1982, he received his Masters of Architecture from Princeton University and moved to Callicoon, New York. Presently, he resides in New York City, where he is the principal in charge of Michael Graves and Associates' New York office. His piano designs are frequently exhibited and are in many private and museum collections. He is currently working on *Facing South*, an 'architectural' opera based upon Olana, the Hudson River estate of Frederic Church.